# Doodle New York City

Published in 2014 by Dog 'n' Bone Books
An imprint of Ryland Peters & Small Ltd

20–21 Jockey's Fields
London WC1R 4BW

519 Broadway, 5th Floor
New York, NY 10012

www.rylandpeters.com

10 9 8 7 6 5 4 3 2 1

A CIP catalog record for this book is available from
the Library of Congress
and the British Library.

ISBN: 978 1 909313 41 5

Printed in China

Editor: Pete Jorgensen
Design: Wide Open Studios
Illustration: Rob Merrett

For digital editions, visit
www.cicobooks.com/apps.php

# Doodle New York City

Draw a day in the Big Apple

**ROB MERRETT**

DOG 'n' BONE

# Introduction

What is New York City? It's the irresistible destination for everyone who wants to be where "it's all happening!" It's a dynamic, non-stop metropolis of exhilarating vitality and uniqueness, a city in a constant state of change and renewal. The din of jackhammers is never far away, as new towering structures seem to appear overnight, rising above their older, iconic cousins in a continuous race for the sky. The city's soaring skyscrapers, the noise of the traffic, and the hustle and bustle of the sidewalks will mesmerize you. Its flourishing art, fashion, food, and nightlife scene will also blow you away. Even the mundane and dilapidated will intrigue—the steam seething from manholes, the faint traces of painted ads on the sides of buildings, the shabby zigzag fire escapes. The list really is endless.

**"I get out of the taxi and it's probably the only city which in reality looks better than on the postcards: NEW YORK."**
Milos Forman, Czech-American film director and screenwriter

Whether you prefer to go on foot, take the subway, or grab a cab, make the most of the many marvels Manhattan has to offer. Discover the delights of Downtown with its abundant über-chic art galleries and boutiques in Soho, Noho, and Tribeca, experience vertiginous Midtown with its glitzy flagship shops and gargantuan upmarket department stores, and embrace elegant Uptown, where the once grand houses of America's 19th Century "aristocracy"—the real-life Gatsbys—are now home to the city's most important art collections.

Take time out to relax and enjoy the peaceful green oases of Gramercy Park, Washington Square, Bryant Park, or Central Park—843 acres of lawn, water, and woodland, considered to be the "front yard" for many New York City inhabitants.

A walk across Brooklyn Bridge will provide you with an exhilarating view of the distinctive Manhattan skyline that is one of the most famous in the world. At night, the city's numerous landmarks are transformed from the familiar into the new with a dazzling light show that amplifies the energy of this incredible city. And if you have time, go further afield to experience the gritty charm of Coney Island, Williamsburg, and Brooklyn.

This doodle book offers you a fun, informative, and eclectic tour of New York City at breakneck speed, with over 100 pages of delightful sketches to complete or create from scratch. There is everything from simple "join the dots" puzzles and adding stick figures to an everyday New York scene to designing fashion accessories and concocting delicious deli snacks. If you know New York City well, draw what you remember from your visits. If you've never been, this doodle book is guaranteed to whet your appetite for "The Big Apple."

Have fun!

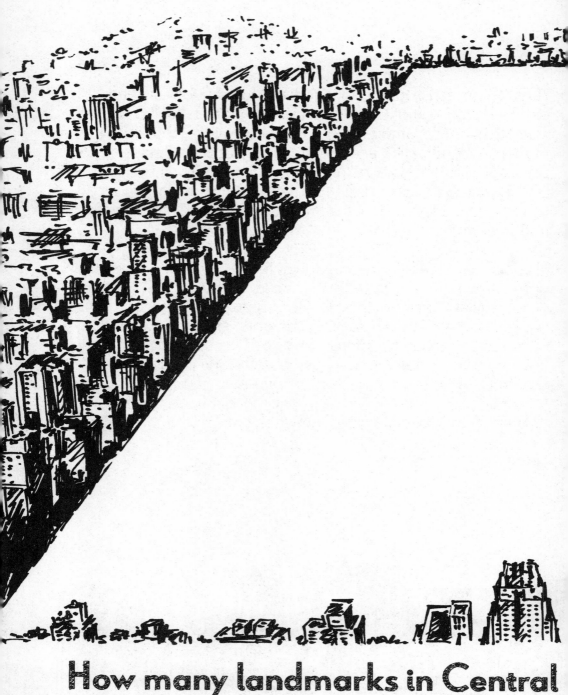

# How many landmarks in Central Park do you know?

Draw as many as
you can think of.

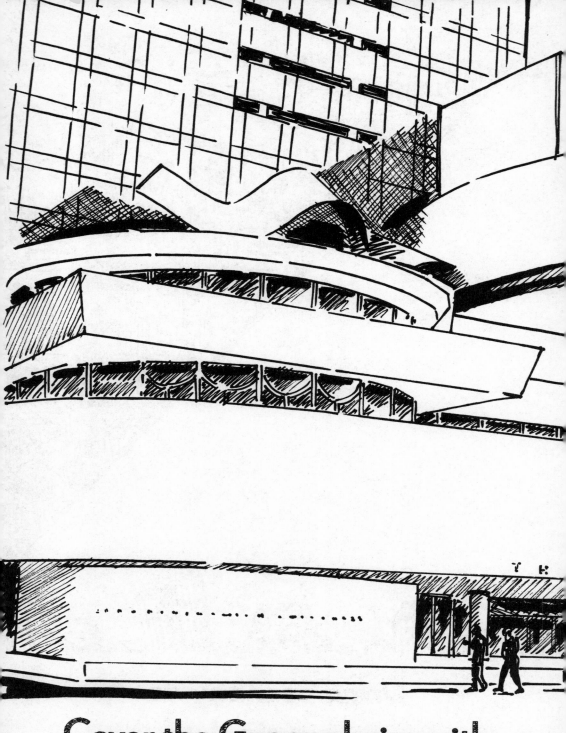

# Cover the Guggenheim with...

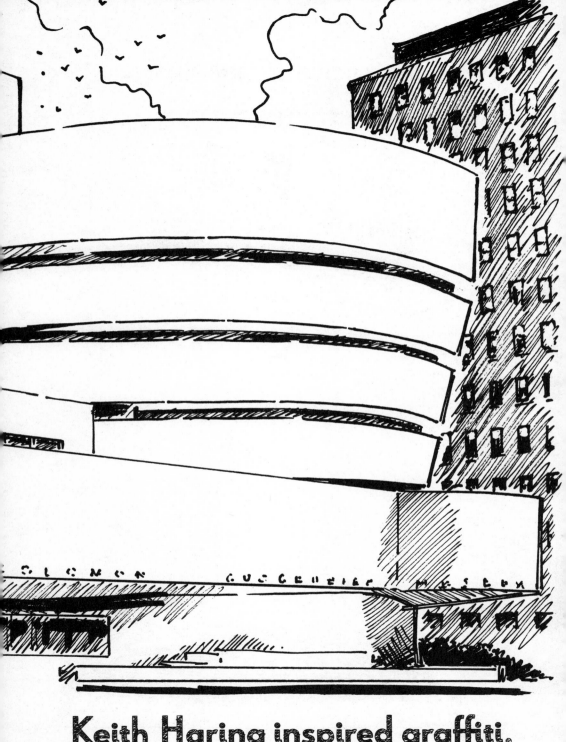

**Keith Haring inspired graffiti.**

# Create a sky high pastrami on rye.

# Add your favorite toppings to these hot dogs.

# Fill in the flags outside the United Nations building.

# Fill the Wollman Rink
# with ice skaters.

# Decorate the Christmas tree at the Rockefeller Center.

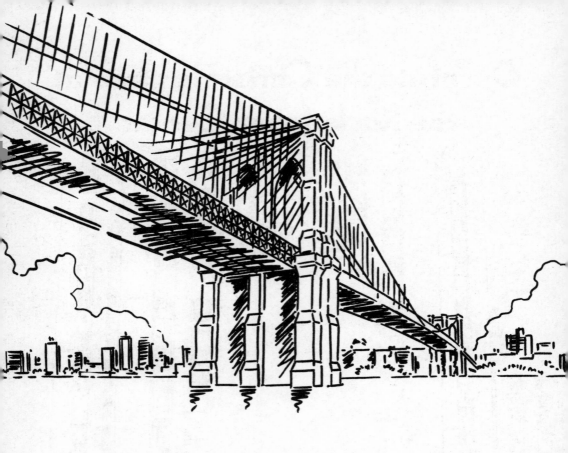

# Reflect the Brooklyn Bridge in the East River...

and continue the Brooklyn
skyline onto this page.

# What can you see on the High Line?

Design skyscraper hats for these
New York socialites.

# Give the classic pretzel shape a new twist.

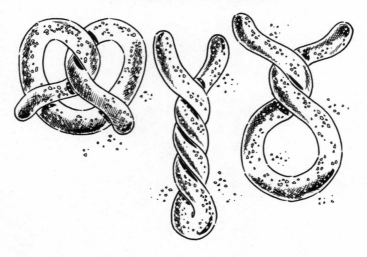

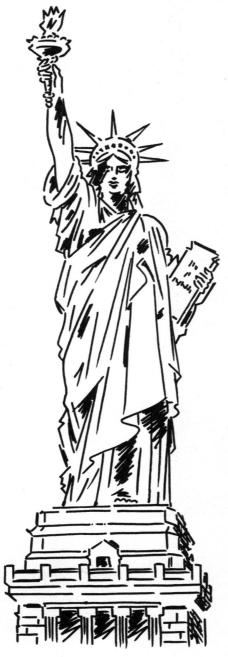

# Celebrate Lady Liberty's birthday with a firework display.

**Create a super-sleek skyscraper.**

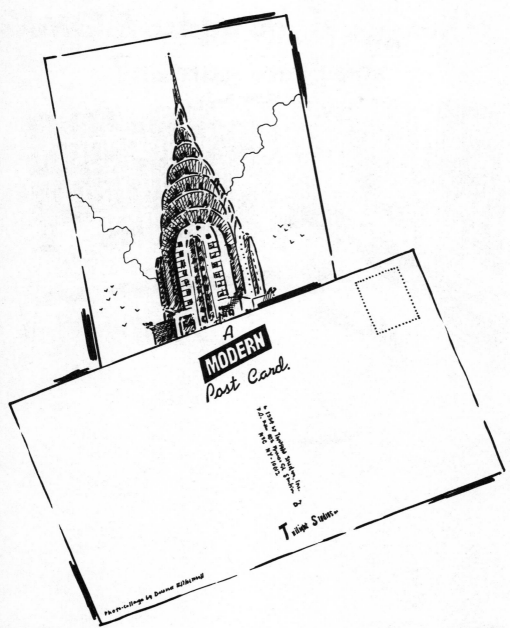

# Write a postcard to your friends back home.

# What would you add to MOMA's sculpture garden?

# Create a magical meadow in Washington Square Park.

Who is escaping from the zoo...

**is it the residents or the visitors?**

Update the ubiquitous
"I ♥ NY" T-shirt.

# Which windows have fire escapes?

# Design your own
# Harlem brownstone.

BERGDORF
GOODMAN

Create a festive window display
for this department store.

# Put something inside this snow globe to remind you of NYC.

# Pile 'em high and add your favorite toppings.

# Complete the San Remo on
# Central Park West.

# Design a kit for your favorite basketball team.

# How does Manhattan look...

 **from the window of your helicopter tour?**

# The top of the Chrysler Building is missing. Design a replacement.

## Create a patriotic hat to wear on Independence Day.

# How do you take your pie? Maybe with a dollop of cream?

# Write down today's specials.

DINER

# Create a tranquil roof garden.

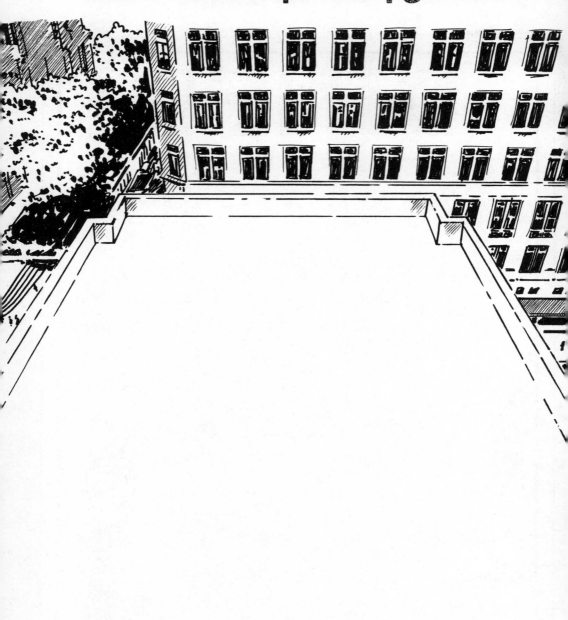

Black out windows to create a
message on this building.

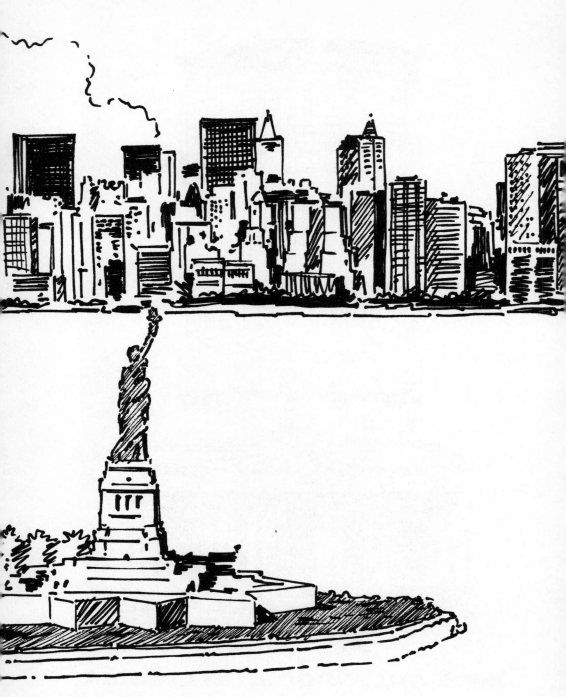

There's a regatta in the harbor.

# Draw a flotilla of sail boats.

# Design gowns to display at the Metropolitan Museum.

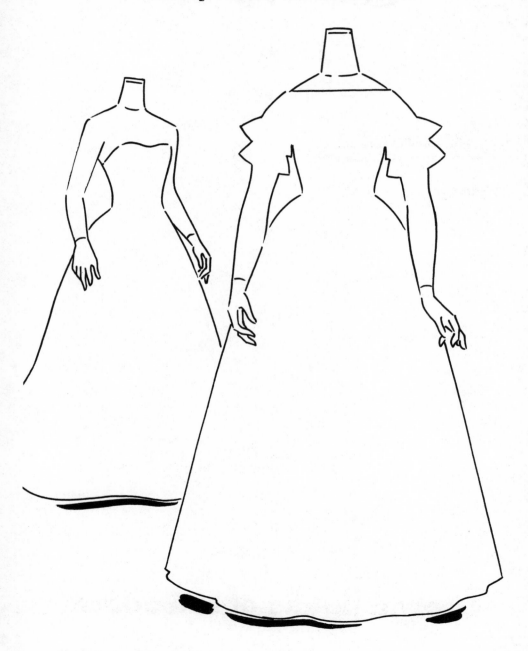

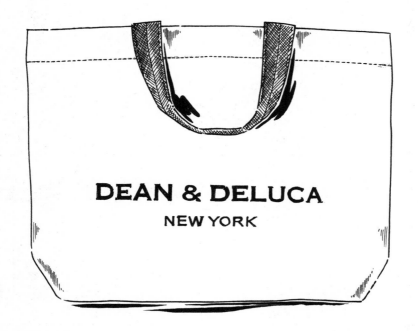

**Fill this tote with gourmet goodies.**

# Join the dots to reveal this famous sculpture outside the United Nations Headquarters.

18•   •19

14•   15•   17•   •20

16•

13•

10•   11•   12•

9•

8•

7•

6•   60•

5•   52•

64•   61•   59•   53•

65•   62•   58•   54•

4•   63•   55•

66•   57•   56•

67•

3•

68•

2•

1•   69•

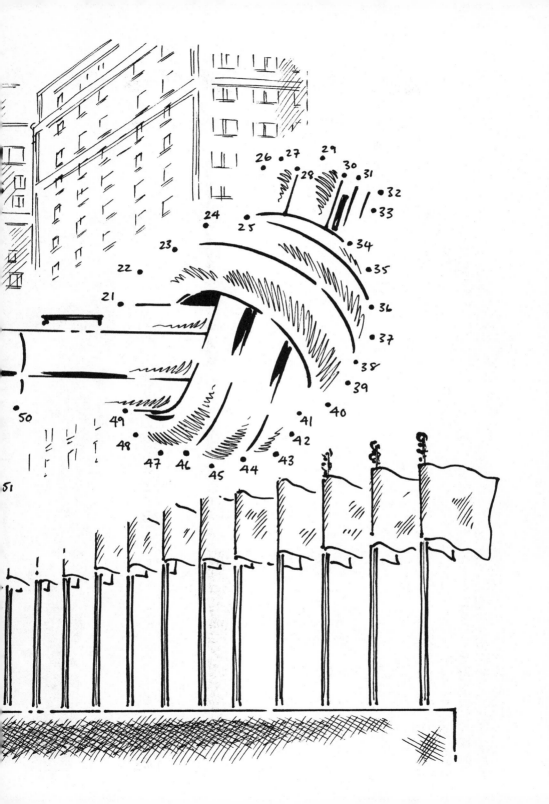

# Create some street art on the side of this high-rise.

# Design balloons for the Thanksgiving Day Parade.

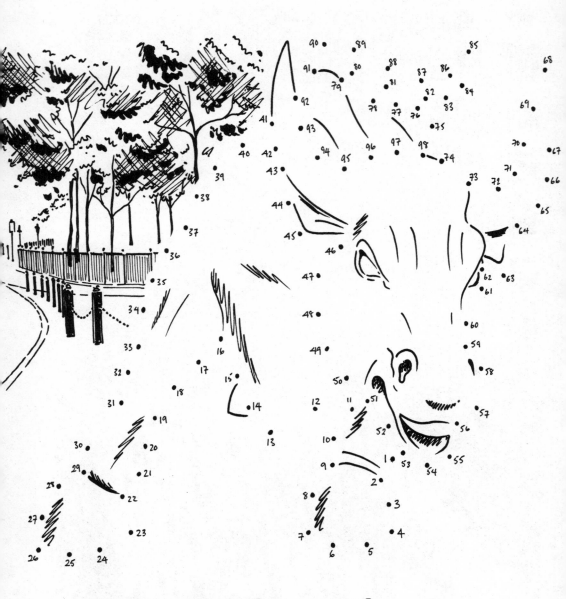

# Join the dots to discover what creature stands in Bowling Green Park.

# Customize the helmets belonging to these New York firefighters.

# Design some cool retro signs...

TIFFANY & CO.

# Design a collection of diamond rings for this famous jeweller.

# What have you bought during your shopping spree?

# Draw on this helmet the logo of your New York baseball team.

# Draw a moustache or beard on each of these Brooklyn hipsters.

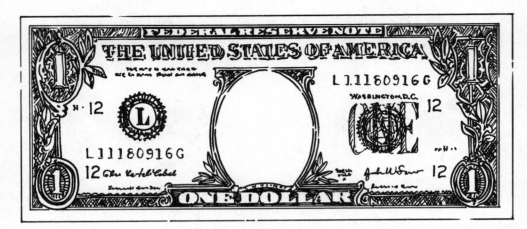

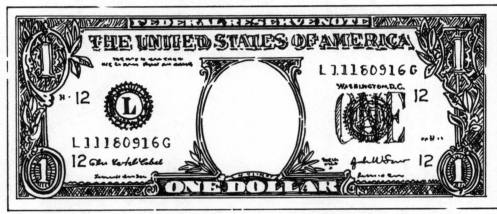

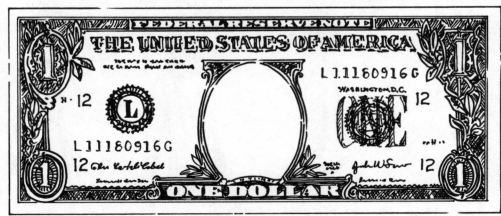

# Draw portraits on these dollar bills.

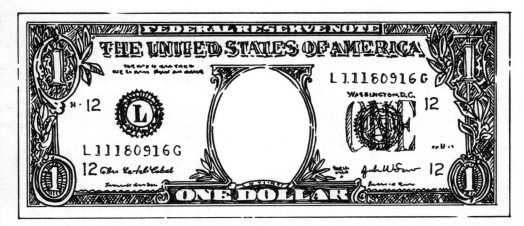

Design a race track...

on Bryant Park's Great Lawn.

# Tag these subway cars...

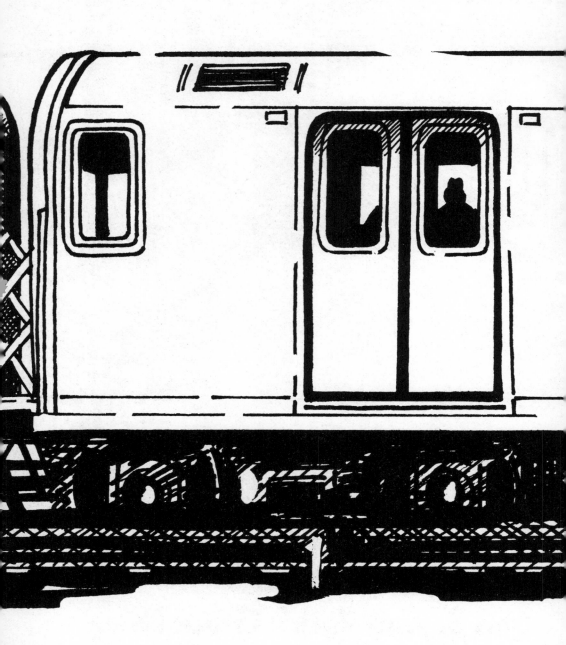

# before the cops can bust you.

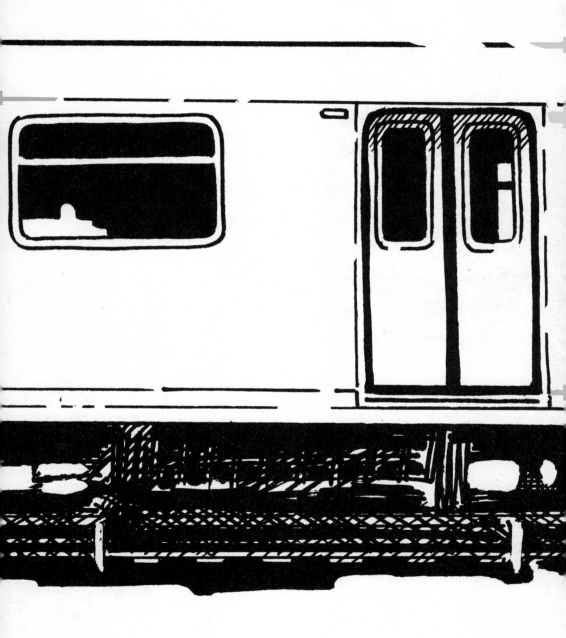

# How many sliders can you and your friends eat?

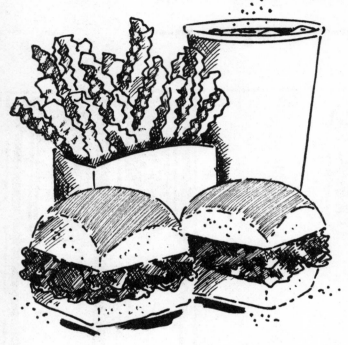

# Join the dots to reveal what this street vendor is selling.

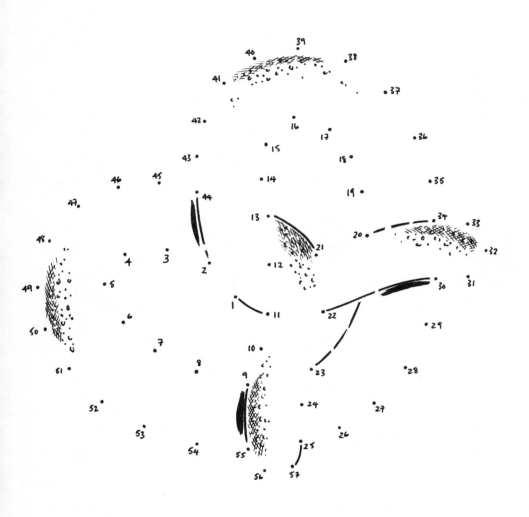

# Customize this T-shirt you picked up at the punk rock club.

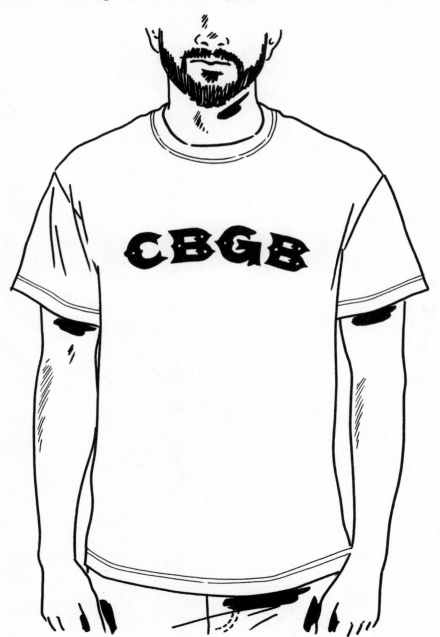

# Design a bonnet and necklace for the Easter Day Parade.

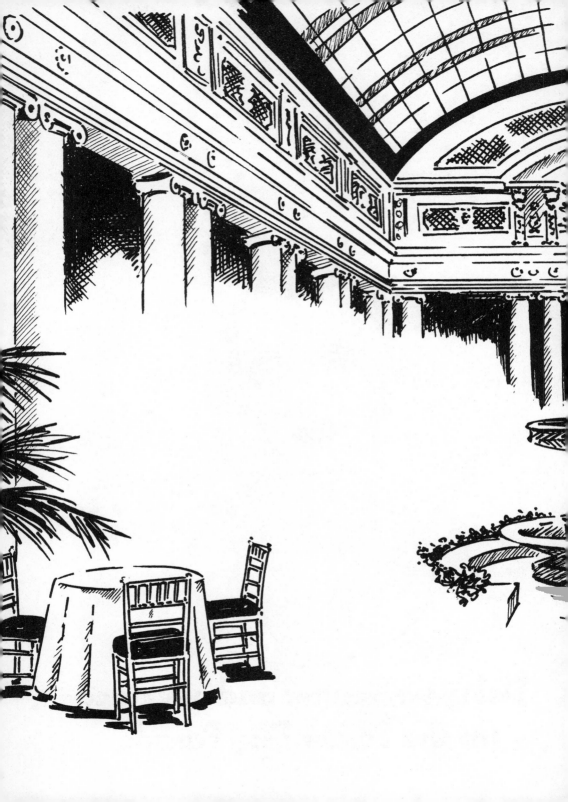

# Host a party for your friends at The Frick.

It's July 4th and the weather is glorious! Fill Coney Island beach with sun worshippers.

# What's Lady Liberty holding in her hand...

**and what's she got on her head?**

# Fill the Staten Island Ferry
## with commuters.

**Create an NYC-inspired tattoo.**

# What's for lunch at this downtown diner?

# Add plaid patterns to the shirts of these hipsters.

**What does this famous store sell?**

**Draw hieroglyphics on the Temple of Dendur at the Met Museum.**

Draw the night owls of Soho.

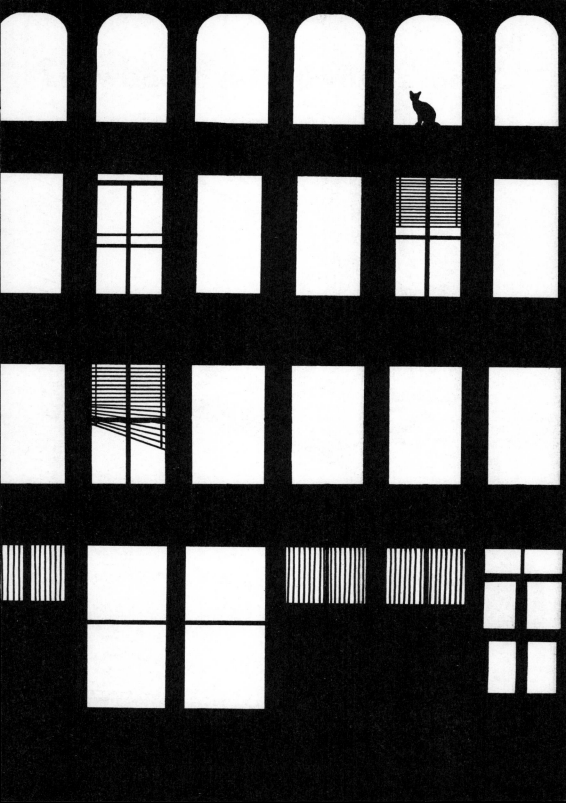

# What's showing on Broadway?

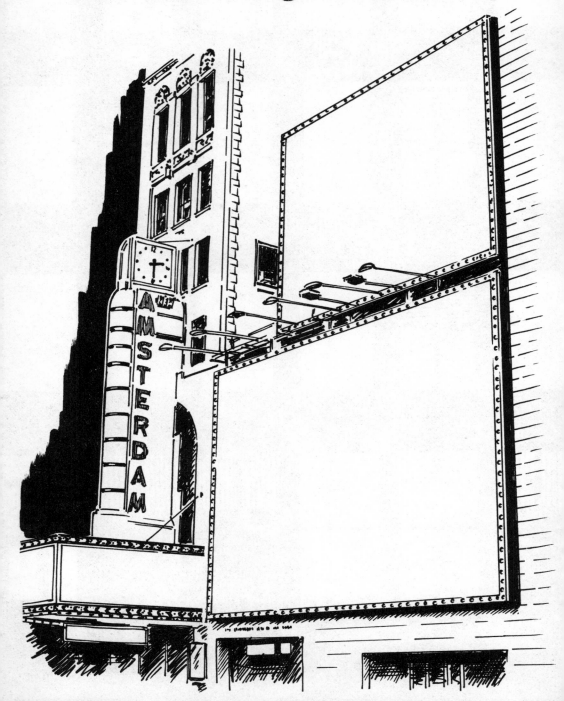

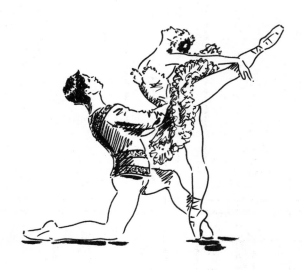

# Design a stage set for
# the New York City Ballet.

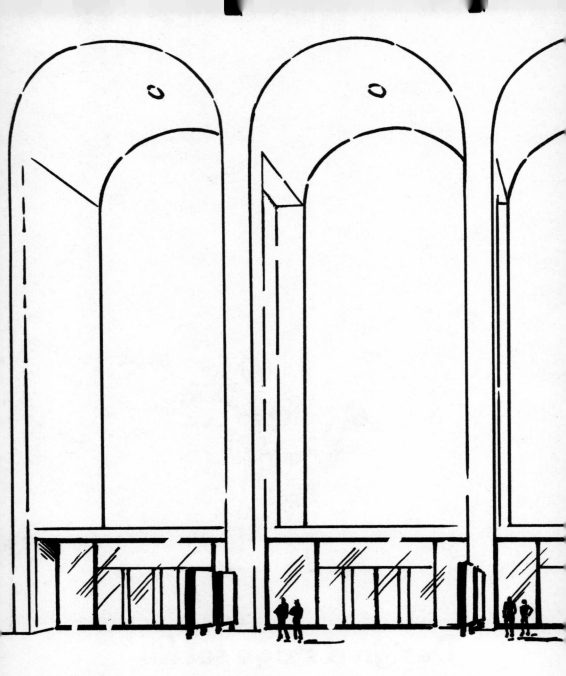

Draw a diva in each arch of...

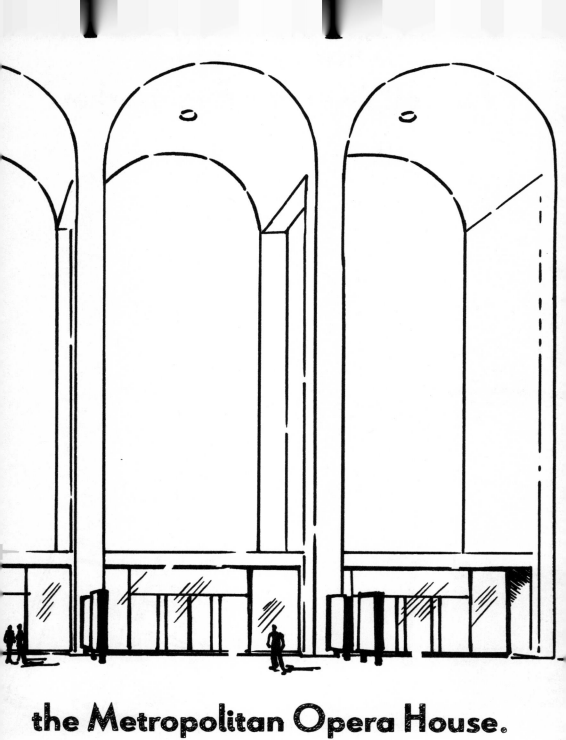

the **Metropolitan Opera House.**

# What's for sale at the Hell's Kitchen flea market?

# How would you furnish your Manhattan condo?

# Give these New York cabs a fresh paint job.

# Design a shield for the NYPD.

# Decorate your nails with NYC-inspired nail art.

# Design skyscraper heels
## for these shoes.

# Create a dazzling display of diamonds.

HARRY WINSTON

# Hang souvenir trinkets from your charm bracelet.

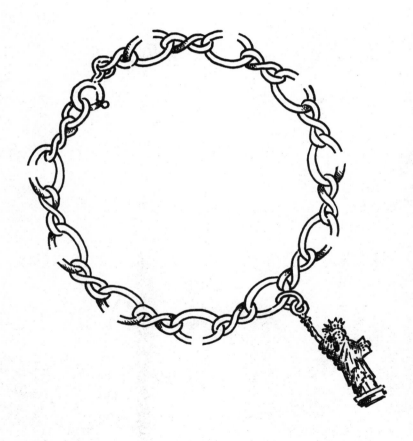

# Draw the zodiac on the ceiling of Grand Central Station...

# along with the 2,500 stars.

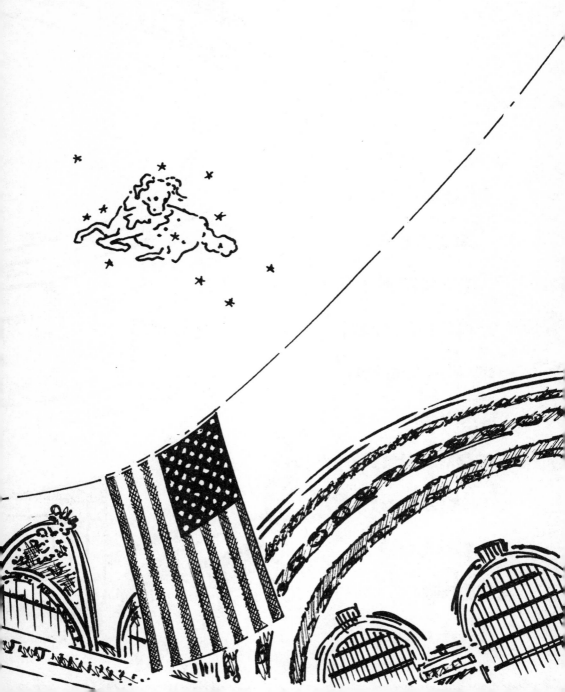

If this is
Madison
Square
Garden,
where are
the flowers?
Cover the
walls with
daisies and
put an
orchard on
the roof.

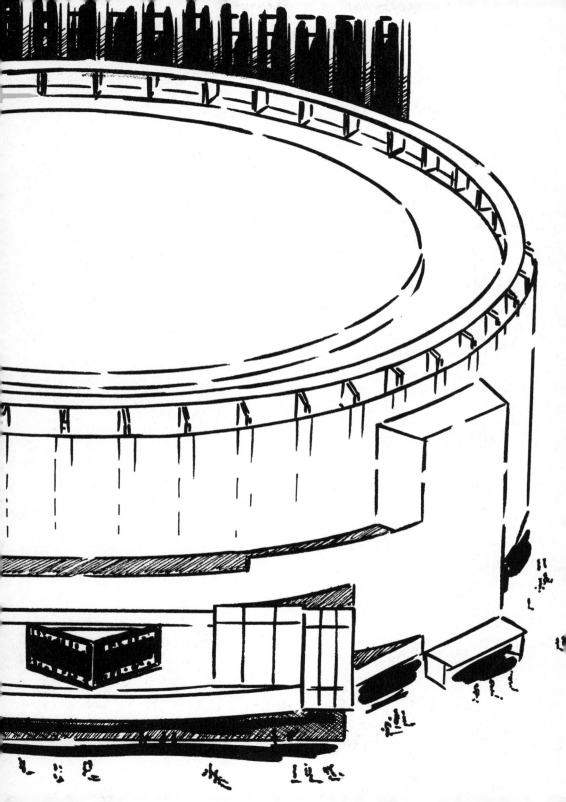

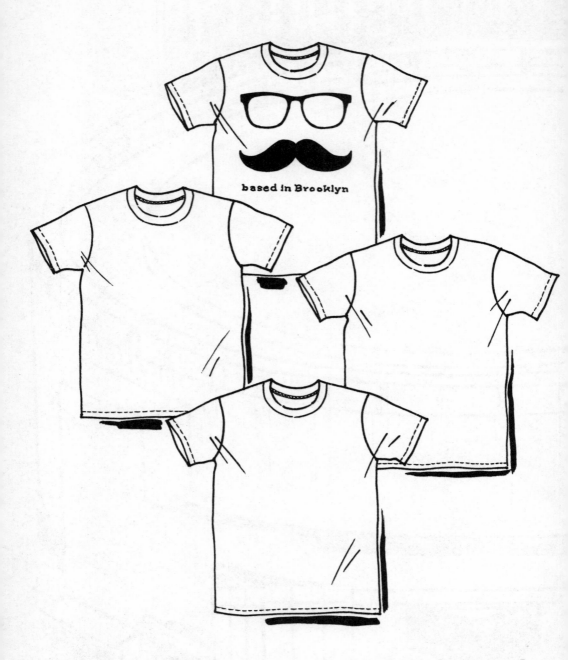

# Design your own 'stache-based hipster T-shirt.

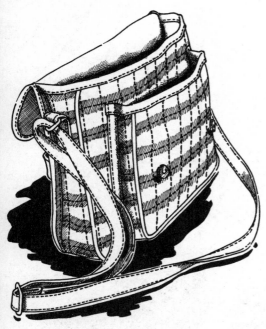

# What's in this hipster satchel?

# Who is this All-American hero?

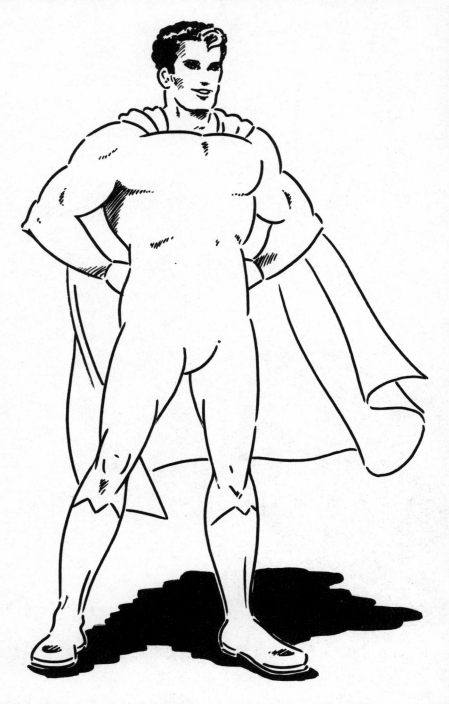

# Bake him patriotic cupcakes to say thanks for saving the day.

# Write an incredible comic-book adventure set in New York.

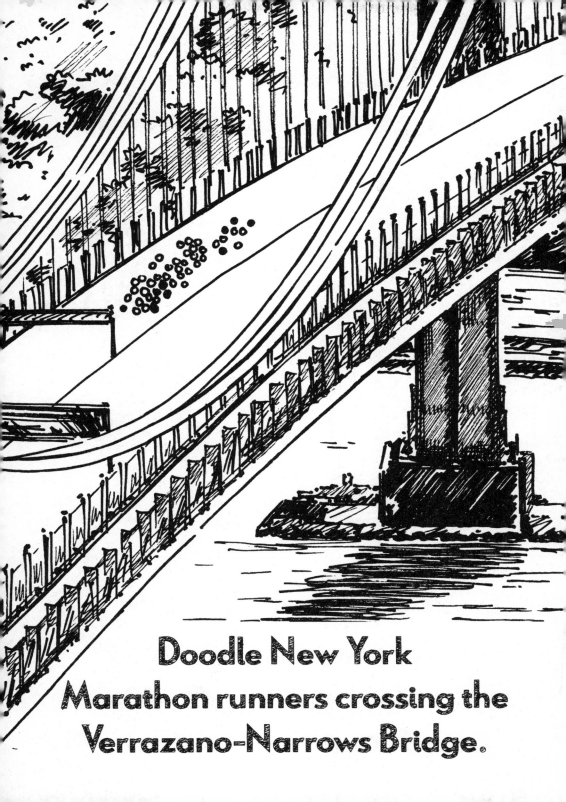

Doodle New York
Marathon runners crossing the
Verrazano-Narrows Bridge.

# Give these Park Avenue pooches chic cold-weather cover-ups.

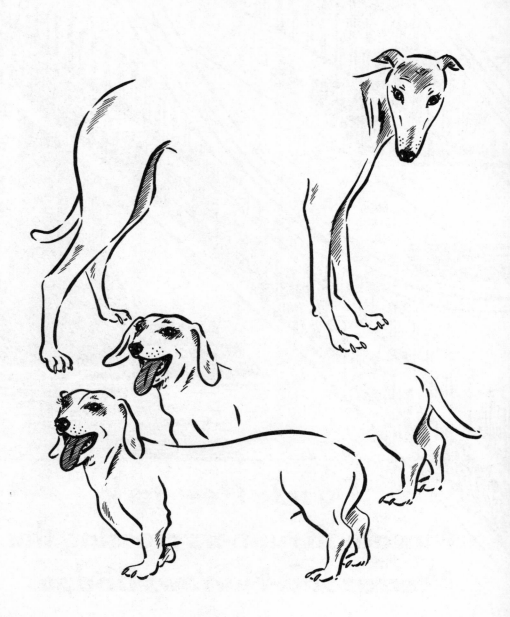

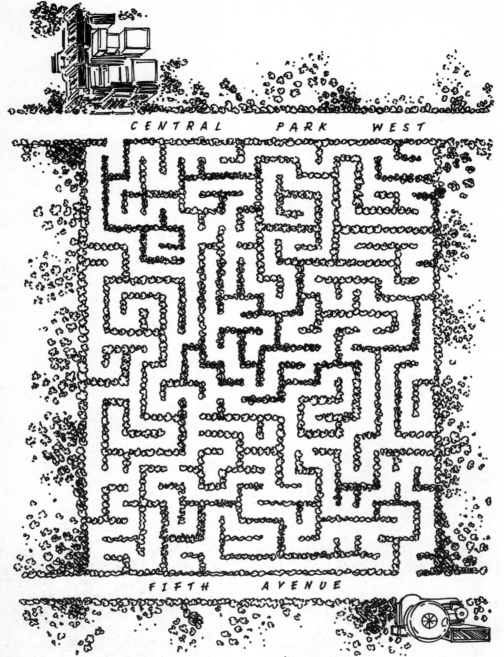

# Find a path from the Natural History Museum to the Guggenheim.

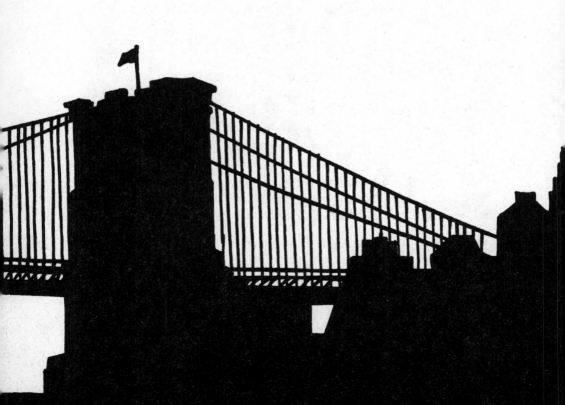

Write a vapor-trail message
high above New York.

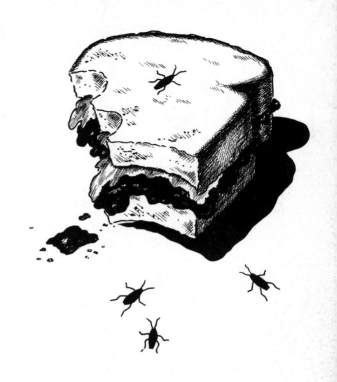

# How many cockroaches are snacking on this PB & J sandwich?

Who's attending
this New York
fashion show?

# Create a masterwork to wow the crowds at MOMA.

# Draw your favorite painting in the Met Museum of Art.

# Decorate your apartment with a New York cityscape wallpaper.

# Draw the lanterns in Chinatown.

# What's going on below ground at this subway station?

Draw a fond memory of your trip to New York.

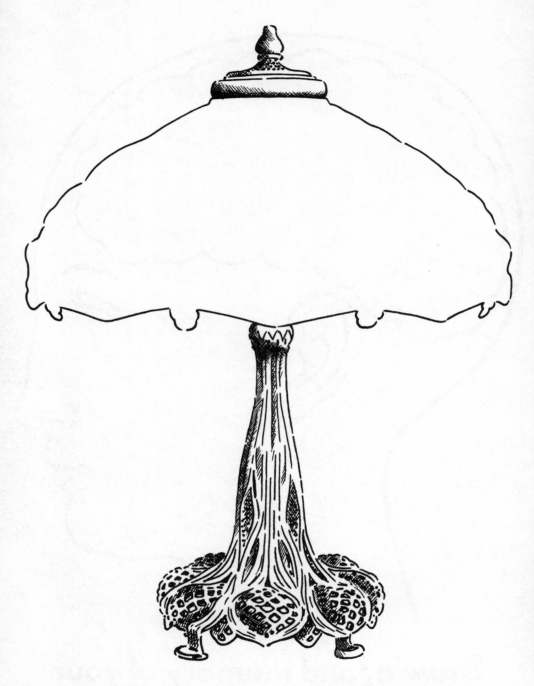

**Decorate this ornate Tiffany lamp.**

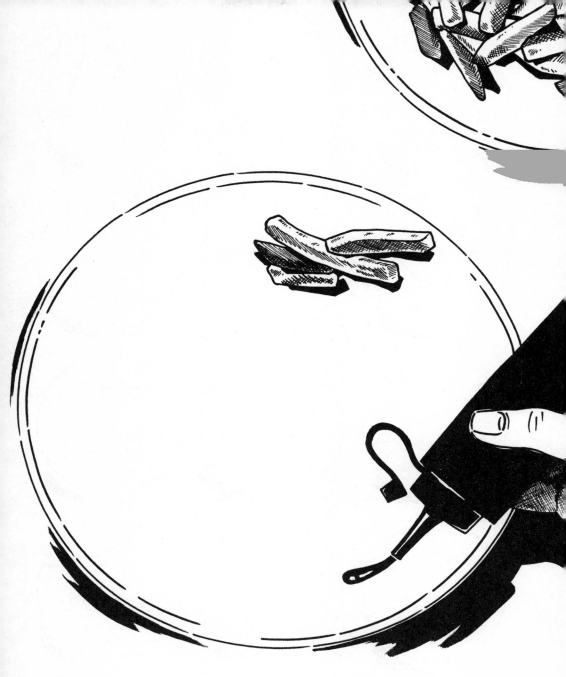

# Write a message for a friend using ketchup.

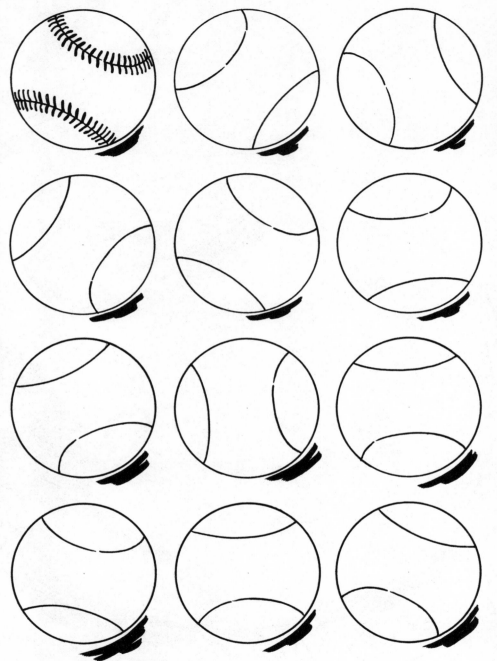

# Add the lacing threads
# to these baseballs.

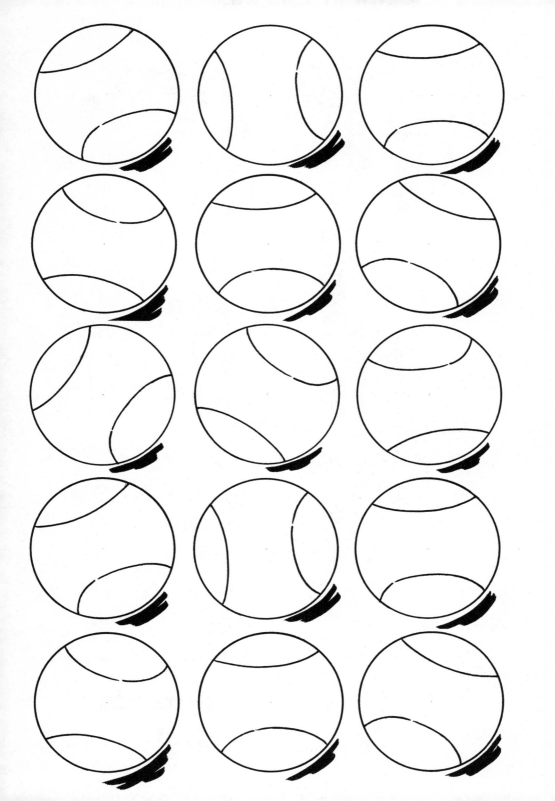